THE WORLD OF DEGAS

Edgar Degas was born in Paris on 19 July 1834. His father, Auguste, had only recently moved to Paris from Naples, coming from a wealthy banking family. Auguste chose to change the spelling of the family name from Degas to 'de Gas' to make it appear as if he came from a noble background. In Paris Auguste met and married an American girl called Celestine Musson. Edgar was their first child. Auguste de Gas was a banker by trade but was very interested in the arts, particularly music and the theatre, and encouraged the young Edgar's artistic interests. Although Edgar enrolled in Law School, he soon abandoned his studies in favour of painting. In 1855 he began attending the École des Beaux-Arts to learn painting, but spent most of his time visiting relatives in Florence and Naples where he studied the works of the great Italian masters. His own work, developed on the belief that drawing was the foundation of good painting, was to match the techniques of the great Renaissance artists such as Leonardo da Vinci and Michelangelo.

Detail of a self-portrait c.1857-60

INFLUENCES & EARLY WORKS

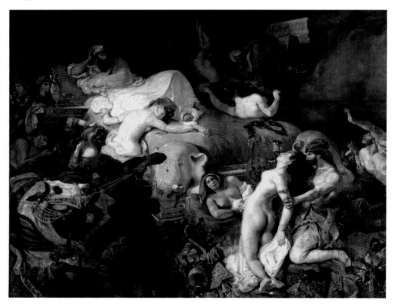

Degas was impressed by the art of the great French and Italian masters and devoted himself to copying their works in order to learn their craft. When he visited Rome in 1857 he filled 28 sketchbooks, drawing obsessively from the art he saw around him, and by 1860 he had copied no fewer than 700 Renaissance and Classical works. In his early career Degas was heavily influenced by Eugène Delacroix and particularly Jean Auguste Dominique Ingres. During his lifetime he acquired 20 paintings and 28 drawings by Ingres as well as works by Delacroix. At first Degas emulated his favourite artists by painting pictures which referred back to the classical school, depicting scenes from ancient Greece, but he soon realised his pictures were out of date and sought new subjects. Realist contemporaries such as the painters Gustave Courbet and Édouard Manet, and the writers Charles Baudelaire and Émile Zola, were convinced that art should reflect real life, rather than romanticised views or themes drawn from classical antiquity. These influences, especially Manet's views, made Degas believe that modern life could be a source of 'heroic' subject matter. Henceforth Degas concentrated on the real world around him.

THE DEATH OF SARDANAPALUS

Eugène Delacroix

Eugène Delacroix was one of the great artists of the first half of the 19th century. His dramatic canvases depicted exotic literary subjects, often stories from north Africa (which he visited in 1832), in direct contrast to the prevailing French classical style of artists such as Ingres. Delacroix's romantic imagery was executed in brilliant colour which made him a favourite of the Impressionist painters who were to follow. Degas was a great admirer of Delacroix, unlike his father, as this excerpt from a letter demonstrates: *'You know that I am far from sharing your opinion of Delacroix, a painter who has abandoned himself to the chaos of his notions and unfortunately for himself has neglected the art of drawing, that keystone on which everything depends.'*

THE SUFFERINGS OF
THE CITY OF NEW ORLEANS, 1865

This painting was the first that Degas had accepted by the French Salon exhibition in 1865. It is not surprising that it received little attention, because Manet's painting of *Olympia* was in the same exhibition and scandalised Paris society. Degas' medieval war scene appeared very old-fashioned when compared with Manet's daring portrayal of a naked Olympia, recognisably a modern-day courtesan. If Degas had intended to comment on the fate of New Orleans, which had been occupied by Union troops in the American Civil War three years earlier, his message had not been made clear.

SEMIRAMIS BUILDING BABYLON

This painting of 1861 is an uneasy combination of the styles of both Delacroix and Ingres. The subject is Semiramis, legendary queen of Assyria and founder of Babylon, who was supposed to have massacred all her slaves after one night of passion. The exotic Oriental story, which would have attracted Delacroix, has been painted in a classical style which borrows from antiquity – quite literally in the case of the horse. The stillness of the scene is reminiscent of Ingres but appears very false and theatrical.

BAIGNEUSE VALPINÇON

Jean Auguste Dominique Ingres

Degas considered Ingres his idol. The two met when Ingres was in his seventies and Degas a young man. In the 1855 Paris World Fair a gallery of Ingres' paintings lacked the painting of *The Bather* because the owner, Édouard Valpinçon, refused to loan it. Degas tried to persuade Valpinçon who was impressed by his pleas and took Degas to meet Ingres. Degas told Ingres he intended to become a painter and received this advice from the master: *'Draw lines, many lines, from memory or nature, and you will become a good artist.'* Degas heeded that advice and often told the story of his meeting with Ingres. Degas' work owes a great deal to the classical lines of Ingres' figures, despite concerning himself with the modern world around him.

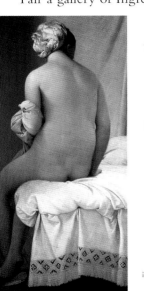

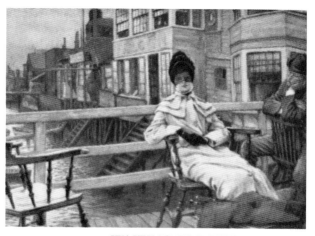

WAITING FOR THE FERRY AT GREENWICH

James Tissot

James Tissot was chiefly a portrait painter who spent much of his time in London rather than his native France. His work is well known for its depiction of Victorian polite society, and is criticised today for being rather shallow and frivolous. In 1874 Degas sent a letter to his friend Tissot in London; *'See here, my dear Tissot, no hesitation and no escape. You have to exhibit on the Boulevard. It will do you good…Manet seems determined to keep out of it and he may well regret it.'* Degas refers to the first exhibition of the Impressionist group on the Boulevard des Capucines. He goes on to describe the Impressionists as the realist movement – *'there must be a realist Salon.'*

THE ART OF HIS DAY

'No art was less spontaneous than mine. What I do is the result of reflection and study of the great masters; of inspiration, spontaneity, temperament, I know nothing.'

What was it that made Degas belong to the group of artists known as Impressionists when he clearly did not regard himself as one of that group? His art was anchored in the classical tradition, summed up by his own phrase: *'Ah Giotto, don't prevent me from seeing Paris, and Paris, don't prevent me from seeing Giotto.'* (Giotto is the 14th-century Italian artist who is considered the founder of modern painting.) In other words he hoped that his adherence to the principles of classical art did not get in the way of his desire to accurately represent the contemporary world around him, and vice versa. Degas exhibited at all the Impressionist group exhibitions except that of 1882. He shared with the Impressionists the desire to capture movement, to observe a scene as a camera would, a 'snapshot' of life without any particular story which needs to be told. Above all he painted exactly what he observed in modern Paris life: the washer-woman, the ballet dancer, the singer, the horse rider.

DÉJEUNER SUR L'HERBE

Édouard Manet

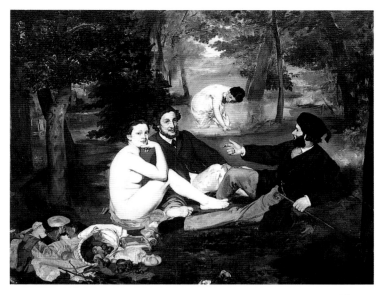

Manet and Degas first met in the Louvre when Degas was copying a painting in the gallery. Manet apparently approached Degas and saw to his astonishment that he was drawing with a needle directly onto the prepared plate rather than making a preparatory sketch to transfer. Manet is reported to have said, *'You have a lot of nerve, you'll be lucky to get anything using that method.'* The two became good friends. Manet's influence on Degas was profound. He was seen as something of a hero leading the realist charge against the old school: his portrayal of Parisian life shocked a society not prepared for such a realistic view of itself.

IMPRESSION, SUNRISE *(detail)*

Claude Monet

In 1874 Degas contributed 10 paintings to an exhibition of works proposed by Monet in response to continued dissatisfaction with the official Salon, which only accepted paintings made in a very traditional style. The show included works by Renoir, Sisley, Cézanne, Morisot and Pissarro, as well as Monet and Degas. As a result, this group of artists gained the name 'Impressionists', after the term used in the title of Monet's painting of a sunrise over the sea at Le Havre. Although Degas exhibited with the Impressionists there were considerable differences between his style and that of others. For example, painting 'en plein air' (outdoors) was at the heart of Impressionism as far as Monet was concerned. He considered it the only way to capture the immediacy of the scene and the changing nuances of light and colour. Degas' view differed saying, *'Don't tell me about those fellows cluttering the fields with their easels…the stupid fools, crouching out there over their stupid shields of white canvas.'*

YOUNG WOMAN AT THE BALL

Berthe Morisot

Morisot was a friend of Degas, despite Degas' rather unfriendly attitude towards women generally. Morisot exhibited her paintings with the Impressionist group as well as appearing as a subject in many of the Impressionists' paintings. Her distinctive style demonstrates freely applied brushstrokes which critics called 'slapdash'. Her friends and contemporaries, however, admired the confidence of her technique which captured the spontaneity so sought after by the Impressionists.

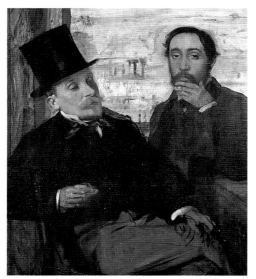

Self-portrait of the artist (above right) with Evariste de Valernnes, 1865.

FAMILY, FRIENDS & OTHERS

*E*dgar Degas came from a large wealthy banking family which had relations in several countries, including America and Italy. His French grandfather moved to Italy, marrying an Italian named Aurora Freppa. They had seven children including Edgar's father, Auguste. Auguste in turn moved back to Paris in the 1830s where he met and married Celestine Musson, an American girl from New Orleans whose family originated from the French slave-owning population in Saint-Dominque (Haiti). Musson's family had moved to New Orleans after the revolution of Toussaint-Louverture. Auguste Degas and Celestine Musson had four children including Edgar. Celestine died when Edgar was 13 years old. Auguste brought up his children alone, educating them at the finest schools in Paris, cultivating in his children a love of the arts, especially music and painting. He often took Edgar to the Louvre to admire the paintings of the French and Italian masters and had his own collection which included many fine works. In a letter to his son, Auguste wrote; '*Follow... that path which lies before you, which you yourself have laid open. It is yours and yours alone... you can be sure you will achieve great things. You have a splendid career ahead of you, do not be discouraged and do not torment yourself... You speak of boredom in doing portraits, you must overcome this for portraiture will be one of the finest jewels in your crown.*'

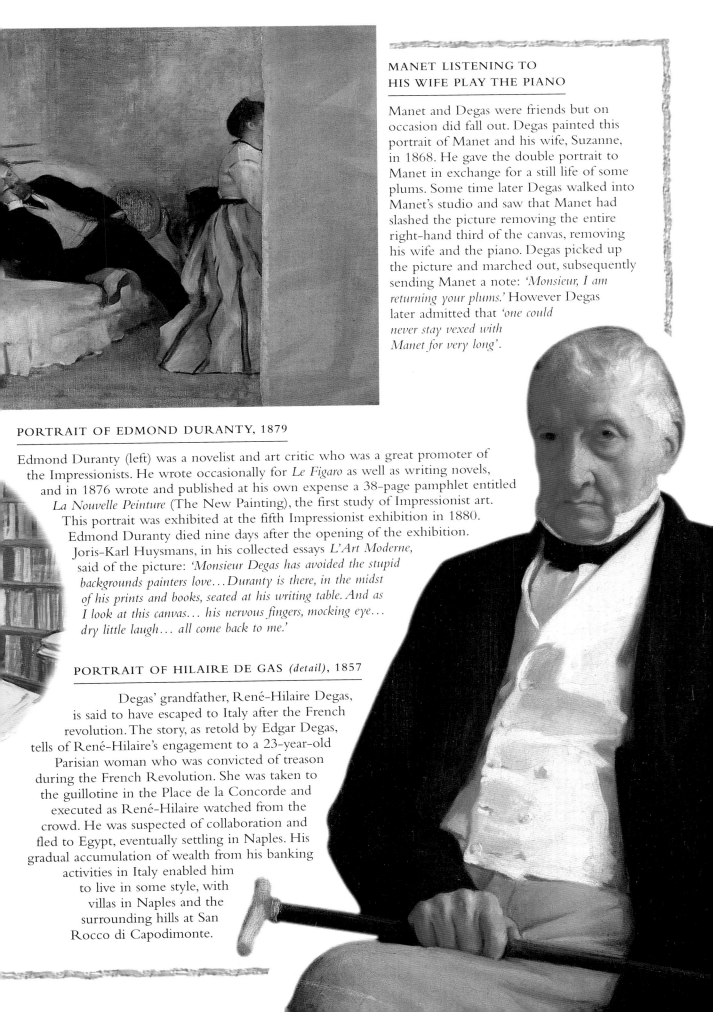

MANET LISTENING TO HIS WIFE PLAY THE PIANO

Manet and Degas were friends but on occasion did fall out. Degas painted this portrait of Manet and his wife, Suzanne, in 1868. He gave the double portrait to Manet in exchange for a still life of some plums. Some time later Degas walked into Manet's studio and saw that Manet had slashed the picture removing the entire right-hand third of the canvas, removing his wife and the piano. Degas picked up the picture and marched out, subsequently sending Manet a note: *'Monsieur, I am returning your plums.'* However Degas later admitted that *'one could never stay vexed with Manet for very long'*.

PORTRAIT OF EDMOND DURANTY, 1879

Edmond Duranty (left) was a novelist and art critic who was a great promoter of the Impressionists. He wrote occasionally for *Le Figaro* as well as writing novels, and in 1876 wrote and published at his own expense a 38-page pamphlet entitled *La Nouvelle Peinture* (The New Painting), the first study of Impressionist art. This portrait was exhibited at the fifth Impressionist exhibition in 1880. Edmond Duranty died nine days after the opening of the exhibition. Joris-Karl Huysmans, in his collected essays *L'Art Moderne*, said of the picture: *'Monsieur Degas has avoided the stupid backgrounds painters love... Duranty is there, in the midst of his prints and books, seated at his writing table. And as I look at this canvas... his nervous fingers, mocking eye... dry little laugh... all come back to me.'*

PORTRAIT OF HILAIRE DE GAS (detail), 1857

Degas' grandfather, René-Hilaire Degas, is said to have escaped to Italy after the French revolution. The story, as retold by Edgar Degas, tells of René-Hilaire's engagement to a 23-year-old Parisian woman who was convicted of treason during the French Revolution. She was taken to the guillotine in the Place de la Concorde and executed as René-Hilaire watched from the crowd. He was suspected of collaboration and fled to Egypt, eventually settling in Naples. His gradual accumulation of wealth from his banking activities in Italy enabled him to live in some style, with villas in Naples and the surrounding hills at San Rocco di Capodimonte.

HORTENSE VALPINÇON, 1871

The Valpinçon family had been acquaintances of the Degas family since Edgar and Paul Valpinçon were at school together. The Valpinçons owned a large house at Menil-Hubert in Normandy, and it was on visits here that Degas first became interested in the racecourse as a subject for painting. Édouard Valpinçon also had a large art collection to which Degas was a frequent visitor. It included a nude by Jean Auguste Ingres which Degas admired above all others (a rear view of a seated bather which today is often known as the Valpinçon Bather). Degas painted this portrait of Hortense in 1871. By the painterly references to the hand movements it appears as if Hortense frequently took bites of the apple.

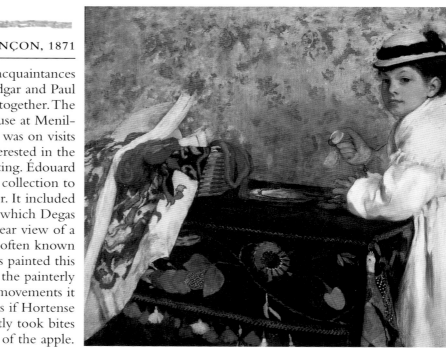

WOMAN WITH A VASE *(detail)*, 1872

The sitter for this portrait has not been positively identified but some people think that it shows Degas' sister-in-law, Estelle Musson. Estelle was already a widow with a young daughter when René de Gas first met her in 1865 and their marriage required a special Episcopal dispensation because they were cousins. Estelle had a tragic life; she contracted ophthalmia, which steadily caused her sight to fail, and by the time of their marriage she was incurably blind. She had five children by René but in 1878 he abandoned her, leaving New Orleans with another woman whom he eventually married. Not long after, four of the six children died. Edgar, disgusted at his brother's behaviour, refused to see René when he returned to France.

THE LIFE OF DEGAS

~1881~
Sculpture of the *Little Dancer of Fourteen Years* is exhibited

~1882~
Paul Durand-Ruel exhibits Degas' work in London

~1887~
Eadweard Muybridge publishes his photographic study of movement, *Animal Locomotion*

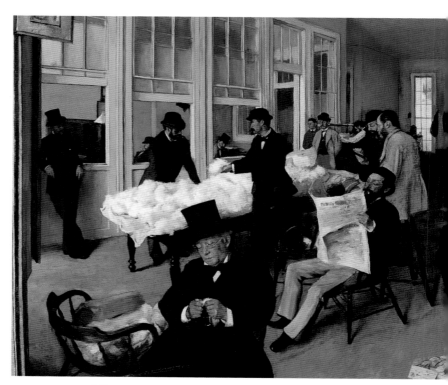

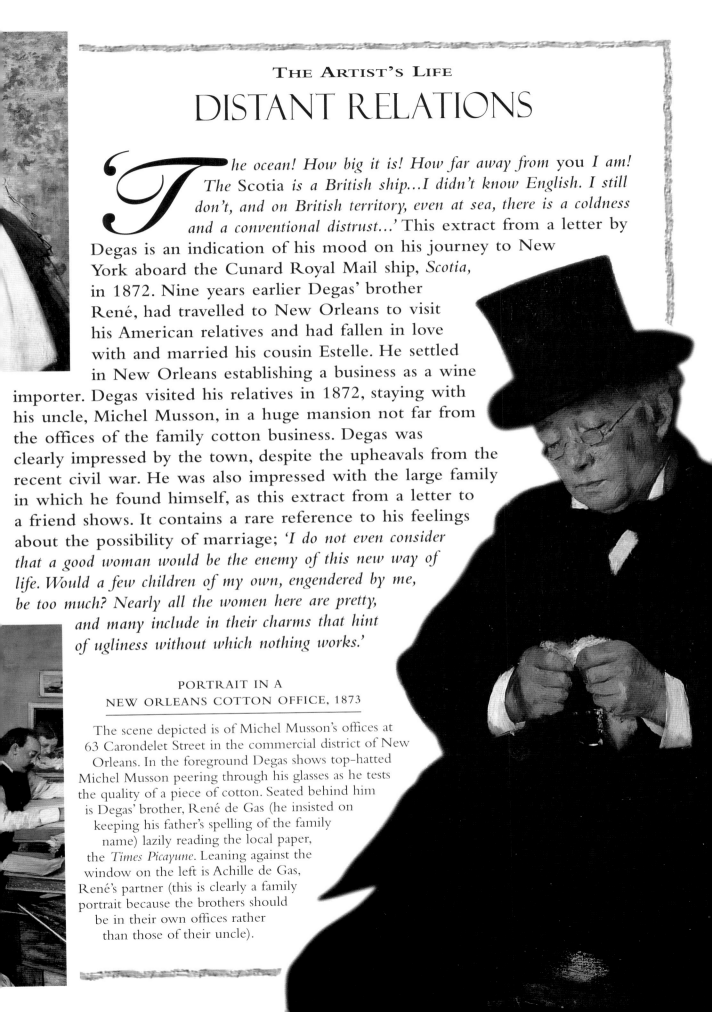

DISTANT RELATIONS

'*The ocean! How big it is! How far away from you I am! The Scotia is a British ship...I didn't know English. I still don't, and on British territory, even at sea, there is a coldness and a conventional distrust...*' This extract from a letter by Degas is an indication of his mood on his journey to New York aboard the Cunard Royal Mail ship, *Scotia*, in 1872. Nine years earlier Degas' brother René, had travelled to New Orleans to visit his American relatives and had fallen in love with and married his cousin Estelle. He settled in New Orleans establishing a business as a wine importer. Degas visited his relatives in 1872, staying with his uncle, Michel Musson, in a huge mansion not far from the offices of the family cotton business. Degas was clearly impressed by the town, despite the upheavals from the recent civil war. He was also impressed with the large family in which he found himself, as this extract from a letter to a friend shows. It contains a rare reference to his feelings about the possibility of marriage; '*I do not even consider that a good woman would be the enemy of this new way of life. Would a few children of my own, engendered by me, be too much? Nearly all the women here are pretty, and many include in their charms that hint of ugliness without which nothing works.*'

PORTRAIT IN A
NEW ORLEANS COTTON OFFICE, 1873

The scene depicted is of Michel Musson's offices at 63 Carondelet Street in the commercial district of New Orleans. In the foreground Degas shows top-hatted Michel Musson peering through his glasses as he tests the quality of a piece of cotton. Seated behind him is Degas' brother, René de Gas (he insisted on keeping his father's spelling of the family name) lazily reading the local paper, the *Times Picayune*. Leaning against the window on the left is Achille de Gas, René's partner (this is clearly a family portrait because the brothers should be in their own offices rather than those of their uncle).

THE FLANEUR

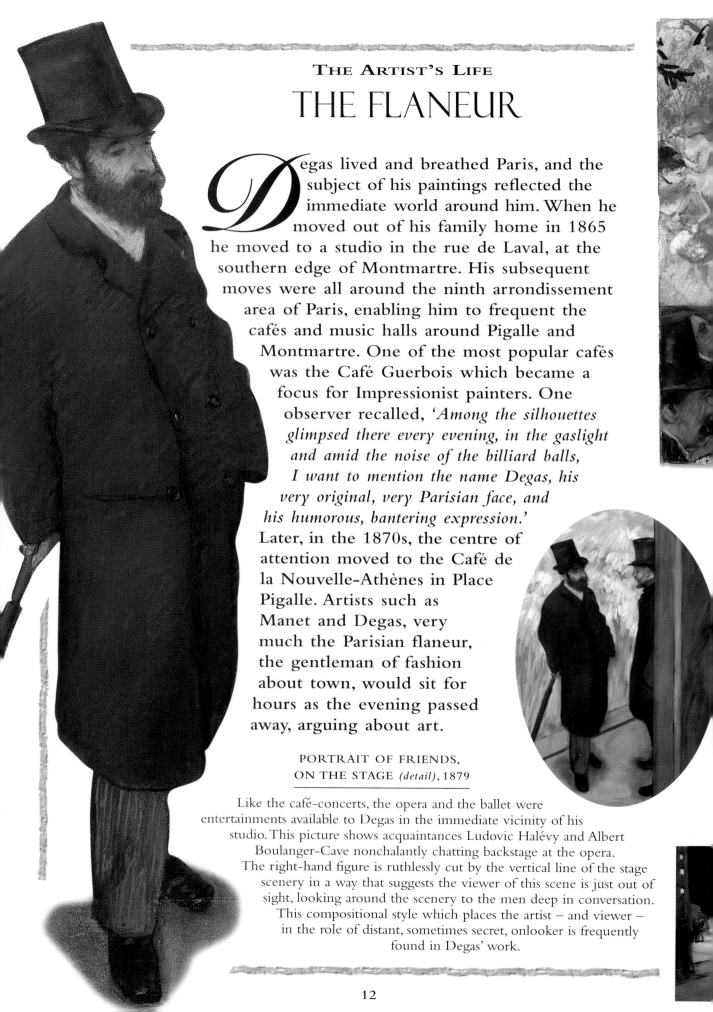

Degas lived and breathed Paris, and the subject of his paintings reflected the immediate world around him. When he moved out of his family home in 1865 he moved to a studio in the rue de Laval, at the southern edge of Montmartre. His subsequent moves were all around the ninth arrondissement area of Paris, enabling him to frequent the cafés and music halls around Pigalle and Montmartre. One of the most popular cafés was the Café Guerbois which became a focus for Impressionist painters. One observer recalled, *'Among the silhouettes glimpsed there every evening, in the gaslight and amid the noise of the billiard balls, I want to mention the name Degas, his very original, very Parisian face, and his humorous, bantering expression.'* Later, in the 1870s, the centre of attention moved to the Café de la Nouvelle-Athènes in Place Pigalle. Artists such as Manet and Degas, very much the Parisian flaneur, the gentleman of fashion about town, would sit for hours as the evening passed away, arguing about art.

PORTRAIT OF FRIENDS, ON THE STAGE (detail), 1879

Like the café-concerts, the opera and the ballet were entertainments available to Degas in the immediate vicinity of his studio. This picture shows acquaintances Ludovic Halévy and Albert Boulanger-Cave nonchalantly chatting backstage at the opera. The right-hand figure is ruthlessly cut by the vertical line of the stage scenery in a way that suggests the viewer of this scene is just out of sight, looking around the scenery to the men deep in conversation. This compositional style which places the artist – and viewer – in the role of distant, sometimes secret, onlooker is frequently found in Degas' work.

CAFÉ-CONCERT AT THE AMBASSADEURS, 1876/7

The 'café-concert' is supposed to have started one night in 1870 when the owner of the Café d'Apollon invited indoors a group of street singers. The mixture of cheap drink and entertainment caught on and there were soon over 200 such café-concerts in Paris, ranging from dingy little bars to grand affairs such as Les Ambassadeurs, with stages and orchestras. Degas delighted in visiting the café-concerts, sketching the crowds and entertainers. A typical café-concert singer of the time was described; *'She is very female, underlining indelicate passages with a gesture and a look and pretty movements of the arms. She has a special way of holding herself, a bit like a bird.'*

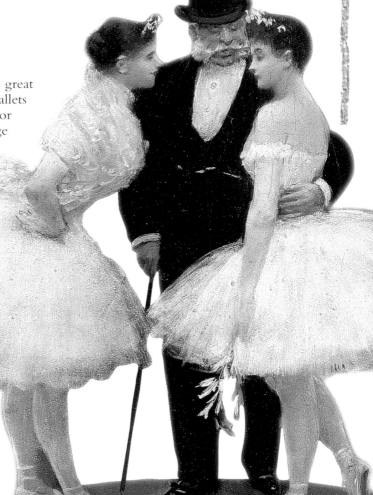

WINGS AT THE OPÉRA

Jean Béraud

French dance in the 1870s was a decadent affair. The great Russian choreographers were yet to arrive, and the ballets performed at the Opéra were for the most part minor entertainments. 'Gentlemen' were permitted backstage where they could flirt with the dancers, and make assignations for after the performance. The wealthier followers sometimes insisted on roles for their mistresses, regardless of talent. The famous composer Hector Berlioz referred to it as 'a house of assignation'. One critic summed it up: *'The man of fashion at the Opéra, with his box or his stall, his favourite dancer, his opéra glasses, and his right of entry backstage, has a horror of anything... artistic, which must be listened to, respected, or requires an effort to be understood.'*

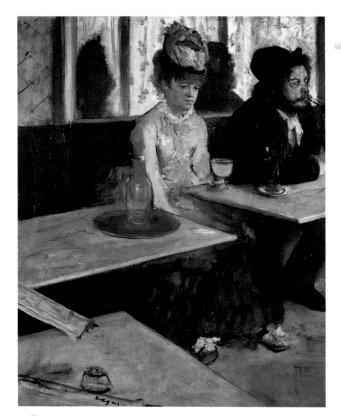

THE ABSINTHE DRINKER, 1876

This painting, originally entitled *Dans un Café* (In a Café), caused an uproar when it was exhibited in Brighton in 1876. The subject matter was controversial because absinthe was deemed responsible at the time for the high rate of alcoholism among the working classes of Paris. No matter that this was an image of real life; the gallery-going public considered it shocking and did not want to be confronted with it. The two sad and downcast figures depicted were in fact friends of Degas.

FAMOUS IMAGES

Two of Degas' best-known paintings are *The Absinthe Drinker* and *Miss La La at the Circus Fernando.* Both reflect his determination to represent the world around him as realistically as possible. Degas said he wanted to portray people in their customary, typical attitudes, with facial expressions matching bodily postures. He recorded fleeting moments, capturing the everyday instances of modern life both in its grim detail and in its gaudy colours. His drawings and paintings combine acute observation with masterful draughtsmanship in the tradition of Ingres. Nothing around him escaped his critical gaze: the café-concert singer, the circus performer, the laundry woman, the ballet dancer. Degas would capture these scenes of modern Paris life in sketchbooks and work up finished pictures in oil or pastel in his studio. Degas' work is famous for the unusual angles he presents onto his scenes. *Miss La La* is a good example but many of his pictures present the spectator with a view of a person or subject which is unconventional – we are more familiar with such angles today as a result of a casual photographic image rather than a planned canvas. This sense of immediacy in his work was planned. Degas' good friend and critic Edmond Duranty described it as *'the sense of modernity as it is caught on the wing'.*

The painter Marcellin Desboutin posed as the male down-and-out, dressed in his usual battered hat and with his clay pipe, despite the fact that he was never known to be anything other than sober.

His female companion, apparently lost in thought and with the glass of green absinthe in front of her, is actress and fashion model Ellen Andrée, considered something of a beauty and the subject of many portraits by artists such as Manet, Renoir and Gervex. Andrée complained that Degas had 'massacred' her in the painting and was also unhappy that he placed the glass in front of her rather than Desboutin.

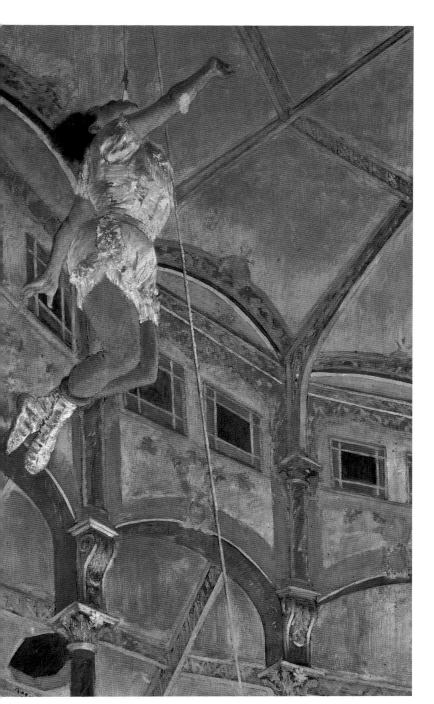

THE BLACK VENUS

Miss La La was known as the 'Black Venus' (she was part African). Her act involved feats of strength with her teeth and jaws. It was at the climax of one of these acts, when Miss La La was being hauled up high into the dome of the amphitheatre at the end of a rope held in her teeth, that Degas chose to paint her.

MISS LA LA AT THE CIRCUS FERNANDO, 1879

Degas decided on the most challenging depiction possible, composing his picture around a view of Miss La La from below as she rises up into the rib-vaulted cupola of the circus. Degas made countless sketches in preparation for the painting, and struggled to achieve the correct perspective for the figure as she is hauled up, rotating as she rises. Degas tried many different poses before settling on the one that conveys the soaring, almost flying figure, her face upturned and her arms and legs striking a ballet position as she begins the dangerous and exciting stunt.

A PROBLEM OF PERSPECTIVE

The view from below looking upwards (known by the Italian renaissance artists as 'sotto in su') was a compositional technique used to create a sense of dramatic movement and space. Degas later confessed that in order to paint the background architecture he called on help from a professional perspecteur who often assisted painters struggling with mathematical perspective.

CIRCUS FERNANDO

The Circus Fernando opened in 1875 in an amphitheatre in the Boulevard Rochechouart, near Place Pigalle, and a short walk from Degas' studio. It attracted artists local to the area, such as Degas and Renoir, who were often found sketching in the circus. However, only one major work by Degas resulted from his visits. Circus Fernando was renamed Circus Medrano from 1890 onwards.

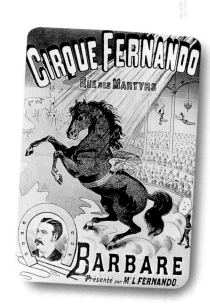

A NEW PASSION

In 1888, the American George Eastman formed the Kodak company which marketed cheap cameras using flexible roll film. Degas bought a portable Kodak camera in 1896 which he took great pride in carrying with him. About that time a friend wrote: *'Degas is abandoning everything in favour of his new lust for photography.'*

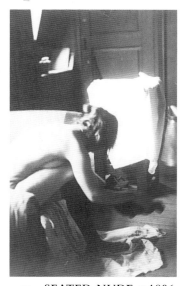

SEATED NUDE c.1896

Photograph attributed to Degas.

WHAT DO THE PAINTINGS SAY?

Observation was everything to an artist and Degas' obsession with it bordered on the voyeuristic. By the 1870s, a new way of observing was available; the camera. Degas became an enthusiastic photographer and had no worries about using this new technology to help him with his art. In fact it changed the way he looked at one of his favourite subjects, the racehorse. Degas made many sketches of jockeys and horses at the track, but he also relied heavily on existing sources such as English sporting prints. Another source to which Degas turned was the artist Jean-Louis Meissonier. His paintings, which included horses in their subject matter, were famous for their 'correctness'. In 1878 the journal *La Nature* published Eadweard Muybridge's experiments of freeze-frame photographs of moving horses. They showed clearly that artists were incorrect when they depicted horses with all four legs outstretched and not touching the ground. Degas was aware of Muybridge's work and may even have attended a presentation he gave in Paris.

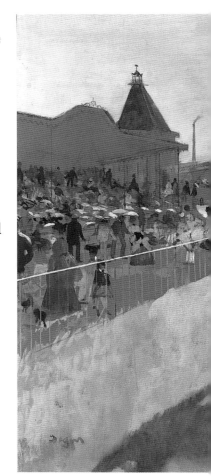

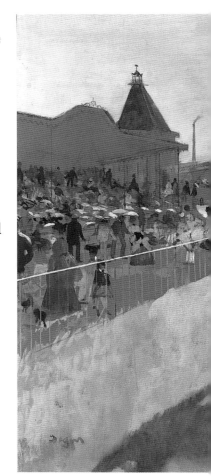

A STEEPLECHASE

John Herring

John Herring was an English artist whose painting *Steeple Chase Cracks* was owned by Degas' father. It can be seen on the wall in the background of Degas' painting entitled *Sulking* (1869).

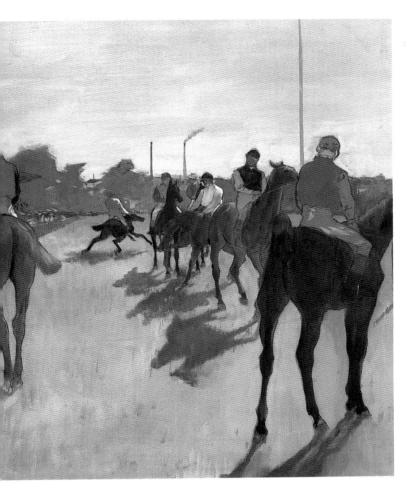

*'And for the manipulations of a bet
He must begin - a dark horse on the field
Nervously naked in its silken robe.'*

These lines from Degas' notebook show that he attempted to capture the skittish elegance of the racehorse in sonnet form as well as in oil on canvas. As far as Degas was concerned the subject was not just about capturing equine grace and beauty; he enjoyed the social occasion of the races. Although many of his sketches show that he worked directly from his subject, it is quite clear that the highly finished drawings and paintings were made in his studio. There he had a dummy horse so that the jockeys who posed for him could adopt the correct posture.

PHOTO SEQUENCE OF RACEHORSE c.1884-5

Eadweard Muybridge

Eadweard Muybridge carried out a number of experiments from the 1870s onwards which involved taking a rapid series of still photographs of moving animals (and humans) to show the successive stages of locomotion. The animals were photographed against a plain background in order to see clearly the various stages of movement. His work was known in Paris in the 1870s but he became famous after the publication of *Animal Locomotion* in 1887, which became a standard textbook on animal and human movement. The book was widely used by artists to assist in the composition of their paintings.

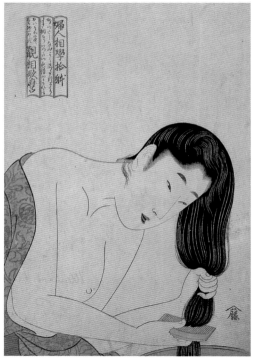

WOMAN COMBING
HER HAIR

Kitagawa Utamaro

The depiction of the act of combing hair has a long tradition in art. Examples can be seen in European painting of the Renaissance period (Titian) and later, such as the picture below by Ingres. It also occurs in art of the Far East, such as the colour wood-block print above by Kitagawa Utamaro, made in 1803 and set in the floating world of the pleasure-houses of Edo.

WHAT DO THE PAINTINGS SAY?

*T*n later life Degas made countless drawings and paintings of women as they bathed and groomed themselves. Critics express different views about these works in which his models are invariably naked. Some are of the opinion that the male scrutiny to which the women are subject means they are exploited as objects.

Others argue that Degas is one of the few artists who does not reduce the female form to a sexual spectacle, but depicts his subjects as believable people going about their everyday tasks. They are shown in awkward positions as they climb from baths or brush their hair. Some of his most intimate pictures are of women combing their hair: an activity that can be read as both banal and tedious, as well as sensuous. In Degas' times it was normal for women to keep their hair long but pinned and coiled out of sight. For 19th-century women the task of washing, brushing and combing long hair was a laborious one, often accomplished with the help of a mother, sister or servant. For men of the time just the thought of such activity, of seeing women with their hair loose, was enough to create excitement.

THE
TURKISH
BATH

*Jean Auguste
Dominique
Ingres*

WOMAN COMBING HER HAIR, 1885/6

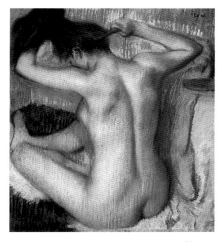

The novelist Émile Zola, an acquaintance of Degas, admitted to being excited merely by the sound of hairpins falling from loosened tresses into a metal washbasin. One of Degas' models is reported to have remarked of Degas to a friend, *'He is odd Monsieur – he spent the four hours of my posing session combing my hair.'* There are also signs of his interest in long hair in one of his very first paintings, *The Sufferings of the City of New Orleans*, painted in 1865 (see page 5). Although Degas never expressed sentiments similar to those of Zola, he did admit to a fascination for observing and faithfully recording the human form and all of its activities. In conversation with the Irish writer George Moore, in 1891, Degas said: *'It's the human animal taking care of its body, a female cat licking herself. Hitherto the nude has always been represented in poses which presuppose an audience, but these women of mine are honest, simple folk, unconcerned by any other interests than those involved in their physical condition.'*

AT THE BEACH, 1876

In this painting Degas portrays a young girl lying on the beach. It would appear from the costume laid out nearby, and from the figures in the sea in the distance, that she has just returned from a swim. A woman (the dress suggests her nurse) bends over the girl, and carefully combs her hair. The young girl toys idly with the edge of the parasol, patiently allowing the woman to attend to her. The painting was executed in 1876, and at first glance would seem to be very much in the Impressionist style. Degas was exhibiting with the Impressionists at that time, and the subject matter – outdoors, the beach, the feeling of immediacy – fitted well. But Degas let it be known that the models *'sat on my flannel vest spread out on the studio floor'* and the background is clearly taken from an earlier pastel entitled *On the Channel Coast*. The hair-combing scene at the centre of the painting was a theme that Degas would return to again over the next 20 years, increasingly depicting it as a very private scene behind closed doors. Degas may have intended a small detail to be deliberately amusing; the smoke from the two steamships on the horizon blows in opposite directions.

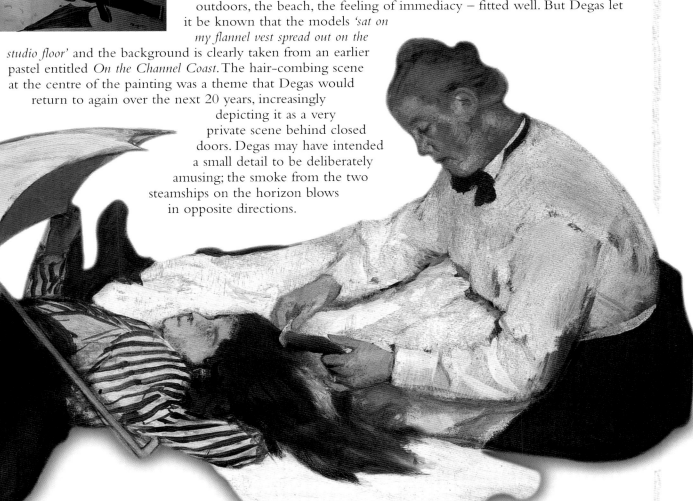

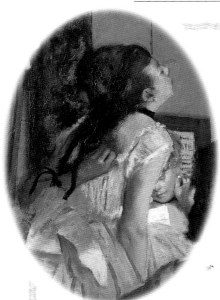

SPONTANEITY

In the foreground a dancer who appears to be perched on a piano reaches awkwardly to scratch her back; her right shoulder half obscures the face of another who fiddles with her earring. These details help to capture the impression of spontaneity.

THE ARTIST'S VISION

THE INVISIBLE OBSERVER

*A*lthough Degas' work covered a wide range of subjects, he is probably best known for his images of dancers. It is estimated that Degas made approximately 1,500 paintings, pastels, prints and drawings of dancers. Very few of the pictures, however, depict the performance itself. Most of the views are not from the auditorium looking onto the stage but from behind the scenes, and particularly of the ballet rehearsal. There was no great tradition of the ballet as a subject for painting although many respectable artists had made portraits of famous dancers in costume. The ballet was however a very popular subject for the 19th-century mass-market, with many cheap lithographs depicting pretty dancers with tiny feet and coy gazes. Degas would certainly have been aware of the popularity of these prints and the prospect of potential sales may have encouraged him to consider the ballet as a subject. Entertainments at the Opera House would have been an obvious attraction given its proximity to Degas' studio. He was drawn to making observations backstage at the *Foyer de la Danse*, where men mixed with the dancers, as well as the stage where the dancers performed.

In the immediate foreground Degas has included a small dog and a watering can. Both serve to enhance perspective, reinforced by the lines of the floorboards which narrow towards the back of the picture.

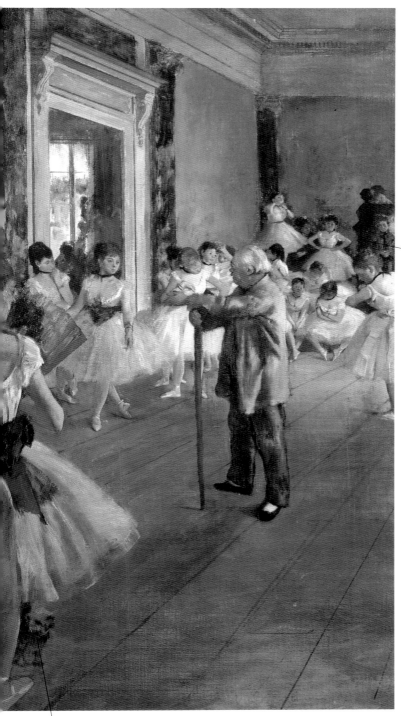

THE DANCE CLASS, 1874

One of Degas' earlier paintings of the ballet is *The Dance Class*. It contains all the elements that fascinated Degas and to which he returned time and time again. The painting captures the rehearsal room atmosphere, full of movement and activity, chattering dancers adjusting their costumes and yawning and scratching, while the teacher watches a dancer go through her steps.

In the far corner, to which the viewer's eye is drawn by the sharply angled perspective, dancers wait with their mothers who fuss over their daughter's costumes. The way the scene is painted reinforces Degas' role as invisible observer. The dancers literally have their backs to the artist as if unaware of his presence.

INFLUENCED BY PHOTOGRAPHY

The apparently arbitrary framing of the scene, which cuts in half the dancer who stands on the far right of the picture, and the manner in which figures overlap each other, is typical of Degas' work. The painting appears to mimic the 'snapshot' effect of a photograph.

The dancer with her back to the viewer, and the empty space at the bottom right of the picture, serve to accentuate the sense of deep space in the painting. This effect is often created by the lens of a camera but seldom experienced by the human eye. Degas' interest in photography would have helped him achieve the very carefully composed image.

The male figure at the centre of *The Dance Class* is Jules Perrot, choreographer and ballet master. He had been a famous dancer in the 1830s and had moved to the Bolshoi Theatre in St Petersburg in 1840 where he stayed until 1849.

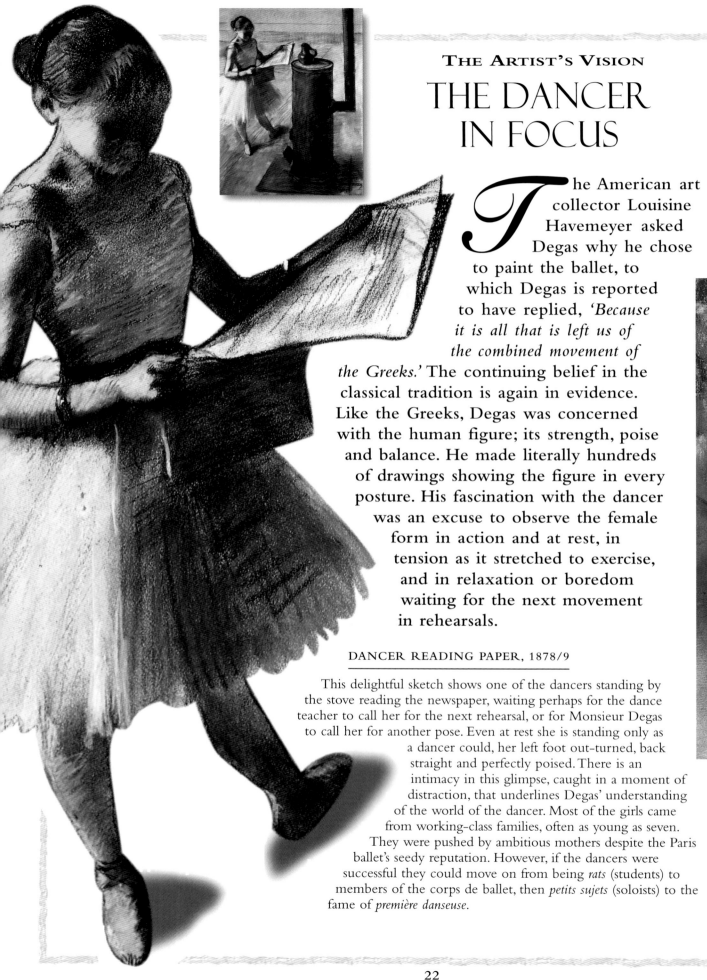

THE DANCER IN FOCUS

The American art collector Louisine Havemeyer asked Degas why he chose to paint the ballet, to which Degas is reported to have replied, *'Because it is all that is left us of the combined movement of the Greeks.'* The continuing belief in the classical tradition is again in evidence. Like the Greeks, Degas was concerned with the human figure; its strength, poise and balance. He made literally hundreds of drawings showing the figure in every posture. His fascination with the dancer was an excuse to observe the female form in action and at rest, in tension as it stretched to exercise, and in relaxation or boredom waiting for the next movement in rehearsals.

DANCER READING PAPER, 1878/9

This delightful sketch shows one of the dancers standing by the stove reading the newspaper, waiting perhaps for the dance teacher to call her for the next rehearsal, or for Monsieur Degas to call her for another pose. Even at rest she is standing only as a dancer could, her left foot out-turned, back straight and perfectly poised. There is an intimacy in this glimpse, caught in a moment of distraction, that underlines Degas' understanding of the world of the dancer. Most of the girls came from working-class families, often as young as seven. They were pushed by ambitious mothers despite the Paris ballet's seedy reputation. However, if the dancers were successful they could move on from being *rats* (students) to members of the corps de ballet, then *petits sujets* (soloists) to the fame of *première danseuse*.

DANCER OF THE CORPS DE BALLET c.1895

This photograph, owned by Degas, was one of many either taken by the artist or arranged by him. It is known that he worked from his photographs but what is unclear is why the originals are collodion glass plates, a photographic process which by the 1890s had long been replaced by newer developments, such as the flexible photographic film and different processing methods. They are however very beautiful images reminiscent of Degas' own renderings of dancers with areas of soft tones leading into sharp contrast and focused detail.

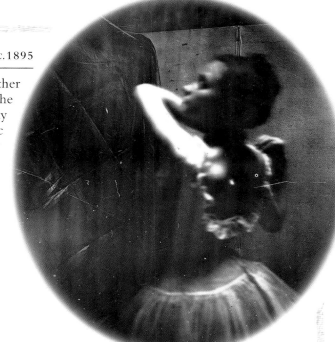

L'ÉTOILE, 1876

In this picture of the 'star', or *première danseuse*, Degas chooses a view from the auditorium towards the stage rather than the more common backstage view. He rarely depicted performances, preferring to attend the rehearsals or have models dressed in costume in his studio. Degas uses a technique known as *repoussoir* (from the French verb *repousser*, to push back) which can often be seen in his paintings. This technique involves a strongly defined (or in focus) person in the foreground, often off-centre, which deflects the viewer's attention towards the rear and enhances the illusion of depth. In this painting the viewer's eye is drawn towards the anonymous male figure watching from the wings. It is also possible to see a reference here to Degas' own position as hidden viewer.

BALLET SHOE FOUND IN DEGAS' STUDIO

Artist Georges Jeanniot described how Degas showed him a dancer's foot.
'He discussed the special shape of the satin shoes held on by silk cords which lace up the ankles... Suddenly he snatched up a piece of charcoal and in the margin of my sheet drew the structure of the model's foot with a few long black lines; then with his finger he added a few shadows and half-tones; the foot was alive, perfectly modelled, its form released from banality by its deliberate and yet spontaneous treatment.'

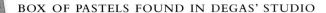

BOX OF PASTELS FOUND IN DEGAS' STUDIO

Degas bought his pastels from artist suppliers such as S. Macle, who provided this box which was found in his studio. Pastels are made from mixing coloured pigments with a binder such as gum and pressing the mixture into moulds. Degas is said to have soaked his pastel sticks in water then allowed them to dry in the sun, thereby testing the permanence of the pigment. His suspicions were caused by the rapid development of new colours which were coming onto the market at that time, many of which proved to be less than satisfactory.

LEAVING
THE BATH, 1895

Despite Degas' admiration of traditional conventions and the classical style, he was an enthusiast of pastels, a medium considered decorative and frivolous by most artists, suitable only for *'the brilliant tints of a young girl, the flesh of a child'*. Many of his pastel works appear to defy his own rules about the importance of line and drawing as the dusty colours explore the shape, tone and hue of the subject. However, the medium is ideal for a draughtsman such as Degas because a stick of pastel is both for drawing lines and colouring areas.

Typically a work began as a drawing and then transformed through veils of local colour, often worked into the paper with fingers. Sometimes the image defies any attempt to identify preliminary sketches or lines, and appears to comprise a single veil of different colours rubbed and merged together. Degas often worked on tracing paper, an unusual choice because the hard shiny surface is particularly unreceptive to pastel. After drawing, hatching and colouring, the image was often fixed with a dilute varnish, sprayed onto the surface, which prevented the soft colours from smudging. Degas then returned to work on top of the fixed surface with more layers of colour which were in turn fixed. Occasionally Degas would use unusual and extreme interventions such as steam, or would scrape away the surface of the paper to get the desired effect.

THE ARTIST'S VISION

HOW WERE THEY MADE?

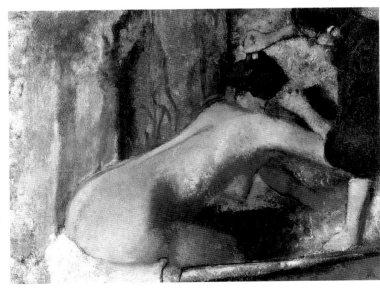

*Standing Dancer, from Behind
(essence on pink paper)*

Degas is acknowledged as one of the greatest draughtsmen of the 19th century. He was a great innovator, experimenting with new techniques to produce the effects on canvas and paper that he was looking for. His ability to represent his subject with extraordinary accuracy, an ability made possible by years of study, gave him the freedom to use a huge range of materials with tremendous confidence. These materials included orthodox media such as oil on canvas, pastel on paper, drawings and watercolours. They also included processes that he devised himself, for example the monotype (single prints), distemper on linen (powdered colours mixed with size) and painting with essence (oil paint thinned with turpentine). Some works, such as *Rehearsal of the Ballet on the Stage*, he painted in watercolour, gouache, oils and finished with pen and ink.

WOMAN AT HER BATH, 1892

Degas' later pastel and oil paintings took on a vibrancy of colour which one observer described as *'the marriage and adultery of colours'*. The intensity of colour reached new heights as his techniques enabled him to create layer upon layer just as the great masters had achieved colour luminosity in oils by building up successive layers of transparent colour. His oil paintings even looked like pastels, with dry paint surfaces and areas of colour that resembled chalk. Critics commenting on his pictures described *'a blue not seen by vulgar eyes'* and *'colours burnt by light, disappearing in passages of greenish flame, falling into embers and pink ashes'*.

HOW WERE THEY MADE?

*D*egas was aware of the oil painting processes used by artists of preceding generations. His respect for such traditions gave rise to problems whereas he felt free and unencumbered by historical tradition when using pastel. Degas eventually found his own way of working in oils that enabled his own inventiveness to build upon traditional methods of painting. He advised the painter Rouart to make a traditional groundwork, let it dry in the open air for a few months, then glaze with colours in the manner of masters such as Titian. But Degas himself used brightly coloured grounds which shone through the subsequent layers of paint, instead of underpainting the canvas in a groundwork of the standard brownish colour (intended to provide the underlying tones). In complete contradiction to his advice to Rouart he also bought lengths of coarse canvas and washed colour direct onto the unprimed surface, then brushed thick paint across it so the dry paint caught on the coarse weave. Painting in oils, the 'cursed medium' as Degas called it, was always a challenge for the master draughtsman.

Palette used by Degas.

STANDING WOMAN IN A BATH TUB, c.1895

The monotype has been in use for hundreds of years but is more or less ignored by artists. Degas 'discovered' the technique in 1874, and in the following years produced hundreds of prints. The monotype is simply a print created by painting an image in oils or inks onto a smooth plate (Degas used copper or zinc) which is then pressed against an absorbent paper, resulting in the transfer of the image onto the paper. It is called monotype because only one (mono) image can be printed. In some cases the whole plate would be covered with a layer of thick ink and by wiping away parts of the ink with a rag, Degas would reveal a 'negative' image. When the plate was printed onto paper the areas of ink remaining on the plate would produce the 'positive' (dark) tones of the print as in this example (right).

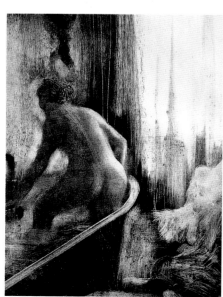

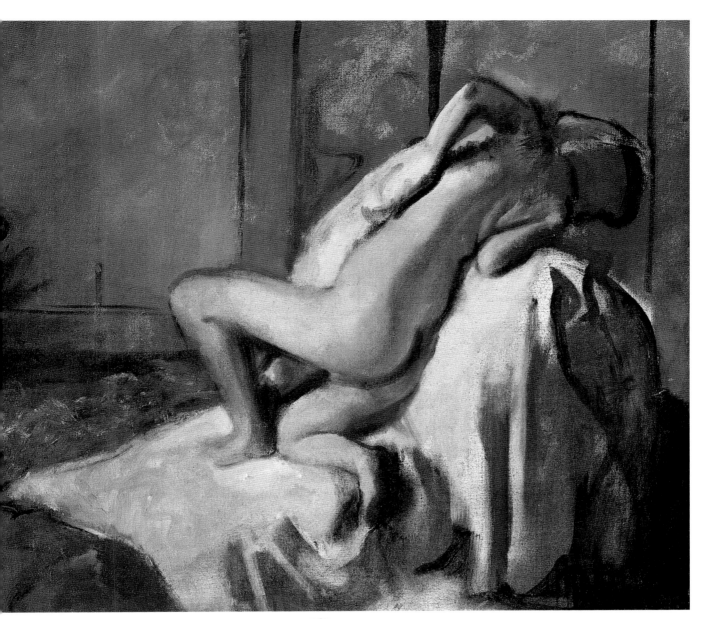

AFTER THE BATH, WOMAN DRYING HERSELF, c.1896

This work was considered by Degas to be unfinished. It appears to be painted in the brownish-reds of the *ébauche* (underpainting) and possibly set aside to dry, but never taken up again by Degas. The posture of the model is far from expectations of normal everyday bathing and drying. Instead we are presented with a torso which stretches the back into a contorted pose. Degas' interest is clearly both to observe the form and musculature of the back, through photography, and to capture the same in oils.

AFTER THE BATH

This is one of Degas' most striking photographs and quite clearly links to his painting made at the same time. He complained that he could get nothing except black paper from the development of his photographs taken in the evening and reluctantly used some of his precious day-time hours, normally reserved for painting, in order to get sufficient light to register a photographic image. He sometimes used carefully placed gas lamps to 'paint' his subject in light before making the long photographic exposure.

This photograph, like many, has carefully controlled light which falls from above (probably from the tall studio windows) across the back of his model, throwing into relief the curvature of the spine and shoulder blades.

PHOTOGRAPH OF
THEO VAN GOGH

Theo van Gogh was a
dealer for the Boussod et
Valadon gallery. He was
one of many visitors to
Degas' studio in the rue
Victor Masse who wished
to promote the artist's
work. In 1888 Theo van
Gogh persuaded Degas to
exhibit a series of pastel
studies of bathers. The
pictures caused a good
deal of excitement and a
handful of the pictures
were sold. Theo was a
great promoter of the
Impressionist's work,
spurred on by the
support he gave to
his brother, Vincent.

THE AUDIENCE & THE CRITICS

Degas' reputation grew in the 1870s as he emerged as one of the main exhibitors with the Impressionist group. He did not have financial worries like some of his fellow artists but his income from his banking family was not large, as some supposed. Degas preferred to keep his pictures unless circumstances necessitated a sale, and then he sold his work directly to the many visitors to his studio or through established art dealers. He shunned the system of one-man exhibitions which had worked so well for his contemporary, Claude Monet, and he refused to exhibit at the official Salon. This distaste for promotion and commercialism was partly as a result of the mauling he suffered at the hands of the critics, and partly to do with his privileged upbringing. One consequence was that few works by Degas were in circulation, and collectors actively sought his paintings. Towards the end of his life his pictures were selling for hundreds of thousands of francs.

DURAND-RUEL
EXHIBITION AT THE
GRAFTON GALLERIES,
LONDON IN 1905

Paul Durand-Ruel (left) was
the driving force behind the
Durand-Ruel galleries. He
arranged for the Impressionist
works, including those of
Degas, to be exhibited in Paris,
London and New York, and
it was this final venue in
America that established the group as a commercial success. More and
more rich American collectors were drawn to this new style of
painting and began to visit the Paris studios in their eagerness to
buy. Success did take time for Durand-Ruel, but in the 1890s
he had established a gallery in New York and works
by artists such as Degas were changing hands quickly.

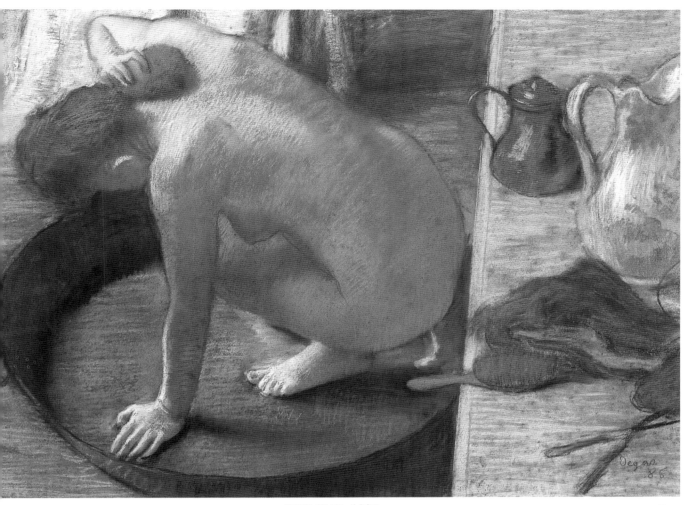

THE TUB, 1886

Critics did not on the whole approve of Degas' pastels of bathers when they first appeared in 1886. One reviewer wrote: *'The woman crouching in a tub, pressing a sponge to her back...these drawings are not done to inspire a passion for women, nor a desire for the flesh... Monsieur Degas, studying them at close range, decomposing their movements, has given them the alarming character of tormented creatures, straining anatomies distorted by the violent exercises they are compelled to perform.'* The English, who were more accustomed to the chocolate box imagery of Victorian women, were direct in their views. London reviews of Degas' dance pictures referred to *'danseuses scantily endowed with beauty... arch, sly, vain and ugly ballet girls.'*

PORTRAIT OF MRS HAVEMEYER

Mary Cassatt

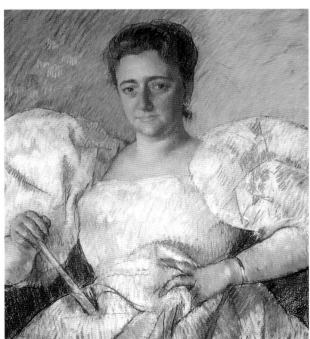

One of the most influential collectors of Impressionist works was Louisine Havemeyer, wife of Henry Osborne Havemeyer, head of the American Sugar-Refining Company. Both Henry and Louisine were avid art collectors but Louisine continued after her husband's death in 1907. In 1912 she paid 478,500 francs for Degas' *Dancers Practising at the Bar.* This portrait is by the female Impressionist painter Mary Cassatt who was a childhood friend of Louisine Havemeyer. When she died in 1929, Louisine bequeathed 36 works by Degas to the Metropolitan Museum of Art in New York.

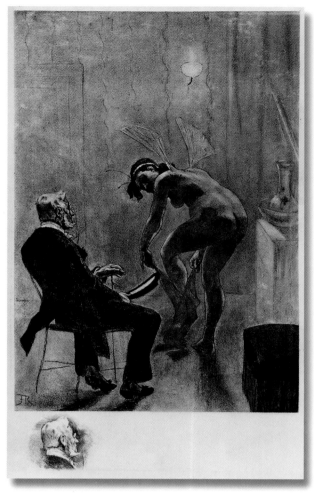

LE MAILLOT

Félicien Rops

Degas saw an army of imitators of both his treatment of dancers and nudes. The characters of *Le Maillot*, drawn in 1893, could have stepped straight from a Degas painting, although Degas always avoided such intimacy.

A LASTING IMPRESSION

Towards the end of Degas' life his eyesight failed and he became virtually blind. As his vision steadily faded, the colours in his pictures brightened in compensation. From about 1900, he was more at ease with sculpture but he more or less gave up art in 1908, at the age of 74, as his eyesight failed. For the last nine years of his life he was unable to work and felt constant despair, repeating *'I think of nothing but death.'* His work became well known and much admired before his death. In 1911, the Fogg Art Museum at Harvard University staged a retrospective of Degas' work. By 1915 his pictures were hanging alongside those of Rembrandt and Rubens at the Knoedler Gallery in New York. When Degas died on 27 September 1917, it started an avalanche of demand for his work and dealers' prices rose sharply. Degas had entered the hall of the famous in the history of art.

COVER OF PAUL VALERY'S BOOK *DEGAS, DANSE, DESSIN*

In 1937 a retrospective of Degas' work opened at the Orangerie in Paris. Increasing interest in the artist's work was met with the publication of poet Paul Valéry's book *Degas, Danse, Dessin* (Degas, Dance, Drawing) and the publication of art historian Lionello Venturi's book *Les Archives de l'impressionnisme*. By 1962 a selection of extracts from Daniel Halévy's diaries recounting conversations with Degas was published and by the mid-1970s Degas' paintings sold for hundreds of thousands of pounds. As a major Impressionist artist, Edgar Degas has become a household name, although his personal story is less well known.

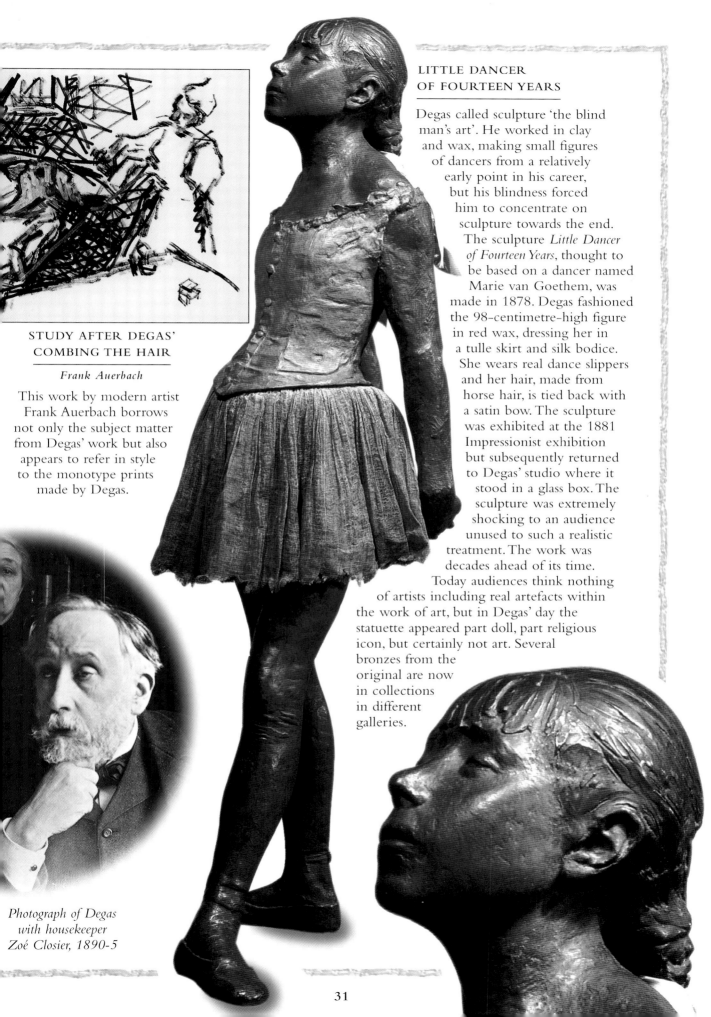

STUDY AFTER DEGAS' COMBING THE HAIR

Frank Auerbach

This work by modern artist Frank Auerbach borrows not only the subject matter from Degas' work but also appears to refer in style to the monotype prints made by Degas.

Photograph of Degas with housekeeper Zoé Closier, 1890-5

LITTLE DANCER OF FOURTEEN YEARS

Degas called sculpture 'the blind man's art'. He worked in clay and wax, making small figures of dancers from a relatively early point in his career, but his blindness forced him to concentrate on sculpture towards the end. The sculpture *Little Dancer of Fourteen Years*, thought to be based on a dancer named Marie van Goethem, was made in 1878. Degas fashioned the 98-centimetre-high figure in red wax, dressing her in a tulle skirt and silk bodice. She wears real dance slippers and her hair, made from horse hair, is tied back with a satin bow. The sculpture was exhibited at the 1881 Impressionist exhibition but subsequently returned to Degas' studio where it stood in a glass box. The sculpture was extremely shocking to an audience unused to such a realistic treatment. The work was decades ahead of its time.

Today audiences think nothing of artists including real artefacts within the work of art, but in Degas' day the statuette appeared part doll, part religious icon, but certainly not art. Several bronzes from the original are now in collections in different galleries.

GLOSSARY

Romantic movement - The Romantic artists were concerned with the expression of passion and the love of the exotic, in direct contrast to those who followed Classicism. Examples of the two styles can be seen in the work of Delacroix, a Romantic, and his contemporary Ingres who painted in the Classical tradition.

Charcoal - This material has been used by artists for centuries and is excellent for drawing on both paper and canvas. It is made from twigs of vine or willow, which are charred by burning in a closed container without air. Charcoal has frequently been used by artists to mark out the first stages of a painting.

Wood block print - A wood block print is a form of engraving. If an unmarked piece of wood is covered in black ink and pressed onto paper, it will leave a solid black impresssion. If lines are gouged into the wood, these lines will show as a white image when the block is pressed onto paper. The block can be used to print hundreds of the same image before it will wear out.

Pastel - Pastels are sticks of colour which are made from compressed dry powdered pigment mixed with gum. Once pressed into moulds and set the sticks are hard but fragile, and their colour is easily transferred when rubbed onto paper. The harder pastels are similar to chalk; softer pastels are similar to oil paints.

Titian - Titian is perhaps the most famous of all Venetian artists. Born around 1490, he was part of the high Renaissance along with Michelangelo. Towards the end of his life he developed a very free style of painting applying patches of colour in a way that seemed to anticipate the Impressionist manner more than 300 years later.

Ebauche - The traditional method of painting in the 19th century required the artist to draw out the picture in charcoal on the canvas, then paint the shadows and tones with a highly diluted reddish-brown colour. Coloured layers were then painted. over it. This brown 'undercoat' was known as the ébauche or sauce.

ACKNOWLEDGEMENTS

Copyright © 2008 *ticktock* Entertainment Ltd.,
First published in Great Britain by *ticktock* Media Ltd.,
Unit 2, Orchard Business Centre, North Farm Road, Tunbridge Wells, Kent, TN2 3XF. All rights reserved.
No part of this publication may be reproduced, stored in a retrieval system, or transmitted in any form or by any means electronic, mechanical, photocopying, recording or otherwise, without prior written permission of the copyright owner.

A CIP catalogue record for this book is available from the British Library.
ISBN 978 1 84696 916 4
Printed in China
9 8 7 6 5 4 3 2 1

Picture Credits t=top, b=bottom, c=centre, l=left, r=right, OFC=outside front cover,
IFC=inside front cover, IBC=inside back cover, OBC=outside back cover.

AKG London; IFC, 2l, 2/3c, 10tr, 28tl, 28bl. Ann Ronan / Image Select; 16tl, 17cb. Archives Durand Ruel; 28br. Biblioteque National de France; 23tr, 30/31cb. The Bridgeman Art Library; 6tl & 6bl, 15br, 16br. © British Museum; 18tl. © 1998 DACS:Frank Auerbach 'Study after Degas's Combing the Hair' / National Gallery (London), Frank Auerbach; 30/31t. Giraudon; 2b, 2t, 3r, 4l, 4/5c, 4/5t, 4/5cb & 5br, 6/7c, 7tr, 6/7cb & 7br, 8tl & OFC, 8br, 9tl, 9br, 10cl, 10/11b & 11br, 12l & 12/13ct, 12/13b & 13br, 14tl & 14br & 14bl, 15t & 15tr, 16/17ct & 17br & OFC, 18bl, 18/19c & 19br, 19tr, 20/21c & 20tl & 20bl & 20br & 21cb & 21br & OBC, 22l & 22ct, 23cl, 24bl & 24r, 25tr, 25br, 27t, 29t. The J. Paul Getty Museum; 16bl, 27cb. Réunion des Musées Nationaux © RMN; 23b, 24tl & 32c, 26cl, 26br. Shelburne Museum; 29br. © Tate Gallery London; 31c & 31br & OBC.

Every effort has been made to trace the copyright holders and we apologize in advance for any unintentional omissions. We would be pleased to insert the appropriate acknowledgement in any subsequent edition of this publication.